FEBRUARY 14, 1998

To Dena,

Wishing you a very,
very, very, very, very, very
Happy Valentine's Day!

Love, Rey

ANIMALPHABET

WITHDRAWN

ANIMALPHABET

VISTA GRANDE PUBLIC LIBRARY

THE METROPOLITAN MUSEUM OF ART • NEW YORK
A BULFINCH PRESS BOOK / LITTLE, BROWN AND COMPANY
BOSTON • NEW YORK • TORONTO • LONDON

T 65613

The works of art reproduced in this book are from
the collections of The Metropolitan Museum of Art.

E
Animalphabet

Copyright © 1996 by The Metropolitan Museum of Art
All rights reserved

First edition

1, Alphabet
2, Animals

Library of Congress catalog card number 95-83457
ISBN 0-87099-764-5 (MMA)
ISBN 0-8212-2286-4 (Bulfinch)

Published by The Metropolitan Museum of Art, New York, and
Bulfinch Press
Bulfinch is an imprint and trademark of Little, Brown and Company (Inc.)
Published simultaneously in Canada by Little, Brown & Company (Canada) Limited

Produced by the Department of Special Publications,
The Metropolitan Museum of Art
Photography by The Metropolitan Museum of Art Photograph Studio
Designed by Tina Fjotland
Edited by Katherine Krupp

Printed in Singapore

"AMONG ANIMALS, *ONE* HAS A SENSE OF HUMOR," WROTE THE POET MARIANNE MOORE, AND THIS ANIMAL ALPHABET BOOK IS FOR THE SILLY GOOSE IN EVERYONE. HERE CREATURES OF ALL KINDS FLY, CRAWL, SWIM, STOMP, AND SLITHER, EACH COUPLED WITH A WITTY DEFINITION.

ANIMALS FROM ALL OVER THE WORLD MAKE THEIR HOME AT THE METROPOLITAN MUSEUM OF ART. AMONG THE FAMILIAR CATS, DOGS, COWS, AND GOATS, EXPLORERS MAY ALSO SPOT AN EXOTIC CHINESE ELEPHANT OF IVORY, A MARBLE POLAR BEAR FROM FRANCE, A FIRE-BREATHING GOLDFISH STUDDED WITH JEWELS, OR A COPPER JAPANESE OWL FLYING IN THE MOONLIGHT. *ANIMALPHABET* BRINGS THESE WHIMSICAL CREATURES TOGETHER IN AN A TO Z HABITAT.

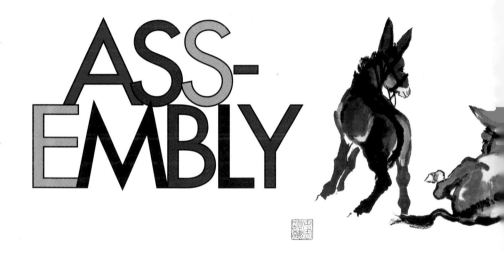

ASS-EMBLY

Donkeys. Huang Chou, Chinese, b.1925. Detail from a hanging scroll, ink on paper.
Gift of Robert Hatfield Ellsworth, in memory of La Ferne Hatfield Ellsworth, 1986 1986.267.444.

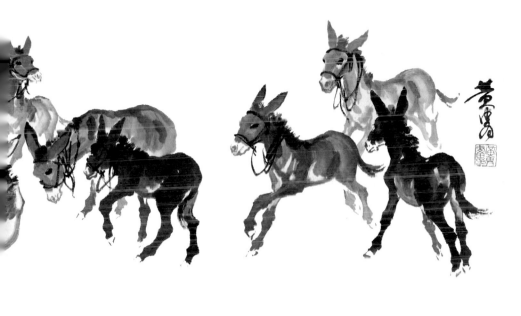

Polar Bear. François Pompon, French, 1855–1933. Marble. Purchase, Edward C. Moore Jr. Gift, 1930 30.123a.

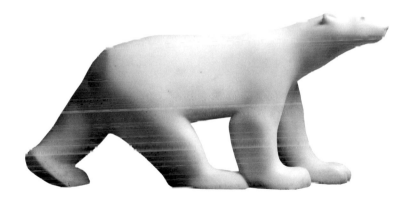

Emblem of Luke the Evangelist. Detail from a bookcover. Italian, 10th–11th century. Ivory. Gift of J. Pierpont Morgan, 1917 17.190.38.

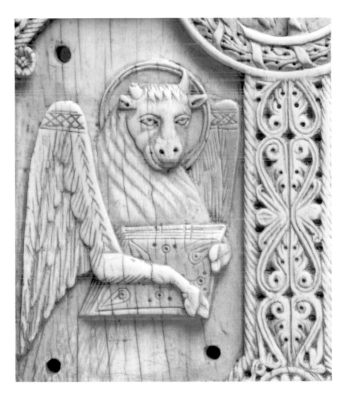

Que pensez-vous de l'expédition? (What do you think of the expedition?)
J. J. Grandville, French, 1803–1847. Colored lithograph from *Les Métamorphoses du Jour*, Paris, 1829.
The Elisha Whittelsey Collection, The Elisha Whittelsey Fund, 1958 58.512.19.

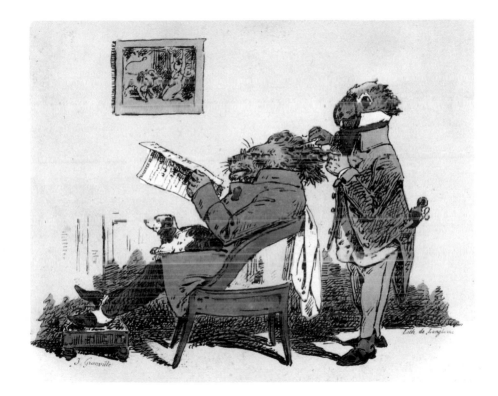

J. Granville

Lith. de Langlumé

King from a Chess Set. Chinese, 19th century. Ivory. Gift of Gustavus A. Pfeiffer, 1953 53.71.171.

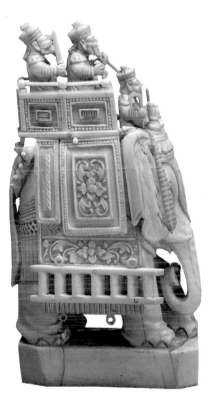

FLY-PAPER

Insect Study. Georg (Joris) Hoefnagel, Flemish, 1542–1600, and Jacob Hoefnagel, Flemish, 1575–1630. Pen and brown ink, colored washes, and gold paint on vellum. Gift of Mrs. Darwin Morse, 1963 63.200.4.

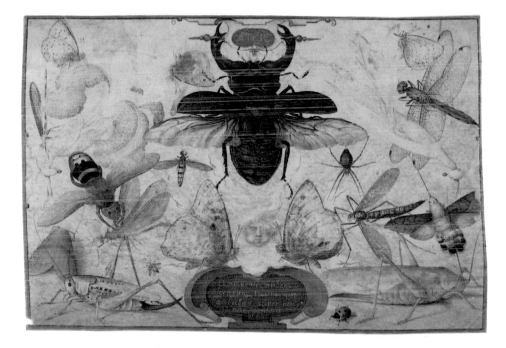

Lighter in the Form of a Fish. Jean Schlumberger (designer), French, 1907–1987. Gold, sapphire, ruby, and silver-gilt; 1939. Gift of Kenneth Jay Lane, 1973 1973.98.

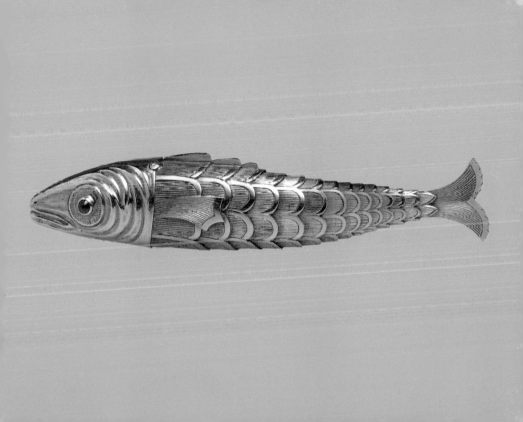

Boar. Stefano della Bella, Italian, 1610–1664. Etching. Purchase, Joseph Pulitzer Bequest, 1917 17.50.17–268.

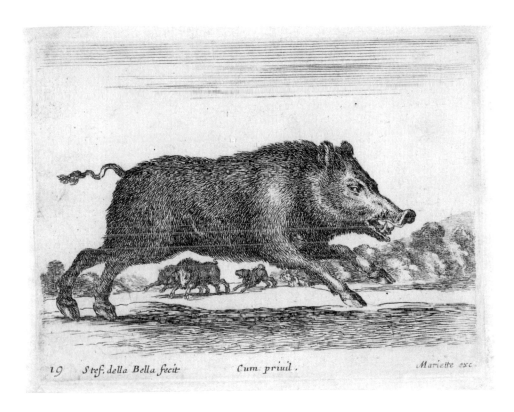

19 *Stef. della Bella fecit* *Cum priuil .* *Mariette exc.*

ITSY-BITSY SPIDER

Spider and Grapevine. Leaf from *Album of Flower and Bird Paintings*. Taki Katei, Japanese, 1830–1901. Ink and color on silk. Gift of Dr. and Mrs. Harold B. Bilsky, 1975 1975.282.1h.

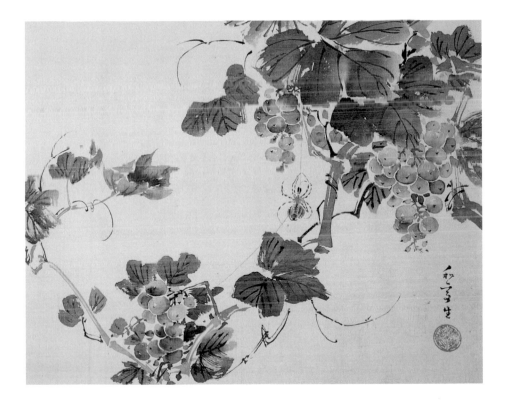

JAILBIRD

Bird in a Cage. Detail from the study from the Palace of Federigo da Montefeltro at Gubbio. Italian, ca. 1478–83. Intarsia of walnut, bog-oak, pear, mulberry, and spindle tree on a walnut base. Rogers Fund, 1939 39.153.

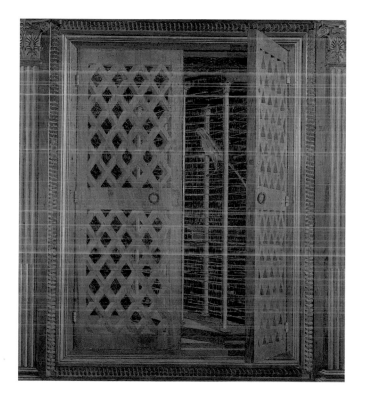

Pussy's Return. Currier & Ives, publishers, American, active 1857–1907. Hand-colored lithograph. Bequest of Adele S. Colgate, 1962 63.550.314.

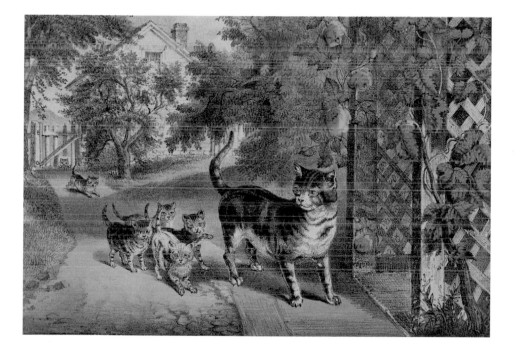

LADYBUGS

The Butterfly at Her Dressing Table. From *Essai de Papilloneries Humaines*. Charles-Germain de Saint-Aubin, French, 1721–1786. Etching. The Elisha Whittelsey Collection, The Elisha Whittelsey Fund and Rogers Fund, 1982 1982.1101.6.

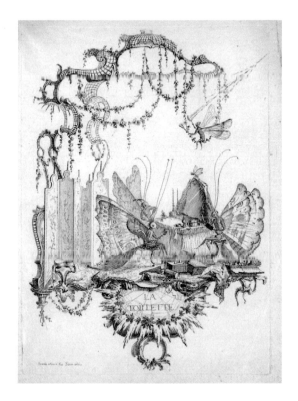

LA
TOILETTE

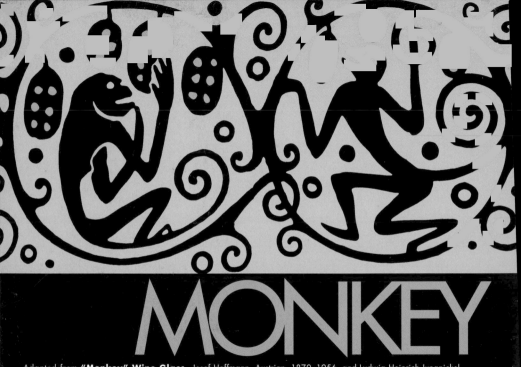

MONKEY

Adapted from **"Monkey" Wine Glass.** Josef Hoffmann, Austrian, 1870–1956, and Ludwig Heinrich Jungnickel (decorator), Austrian, 1881–1965. Painted glass, 1910–11. Manufactured by J. & L. Lobmeyr for the Wiener Werkstätte. The Cynthia Hazen Polsky Fund, 1993 1993.323.

Kashira (sword pommel) with Owl and Moon. Masamitsu, Japanese, 18th century. Copper, gold, and silver. The Howard Mansfield Collection, Gift of Howard Mansfield, 1936 36.120.459b.

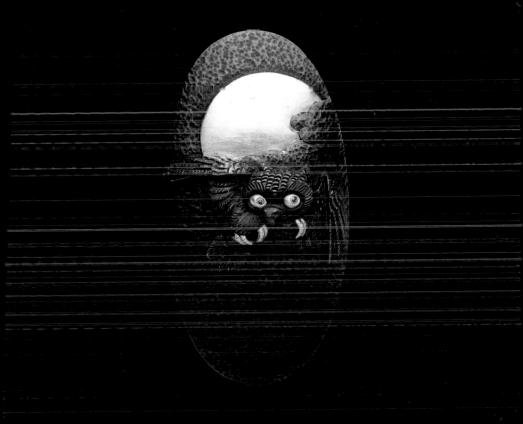

Plaque with Goat. Mesopotamia, Neo-Assyrian Period, Nimrud. Syrian style, 8th century B.C. Ivory.
Rogers Fund, 1961 61.197.6.

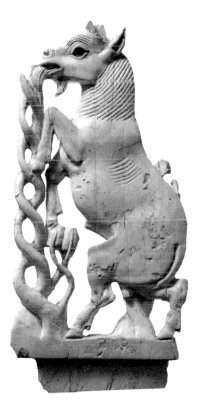

At It Again. Rollin Kirby, American, 1875–1952. Lithographic pencil and tusche on cardboard, 1920. Gift of the artist, 1944 44.16.8.

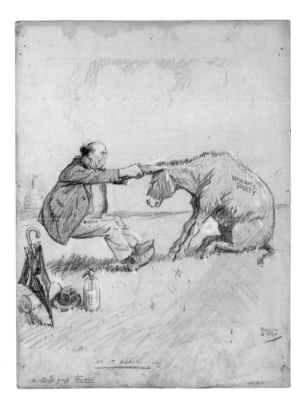

BRYAN

DEMOCRATIC PARTY

ROLLIN KIRBY

AT IT AGAIN!

Bee from a Crazy Quilt Top. American, New York State, ca. 1885. Silk, silk velvet, and cotton. Gift of Tracy Blumenreich Zabar, 1989 1989.66.

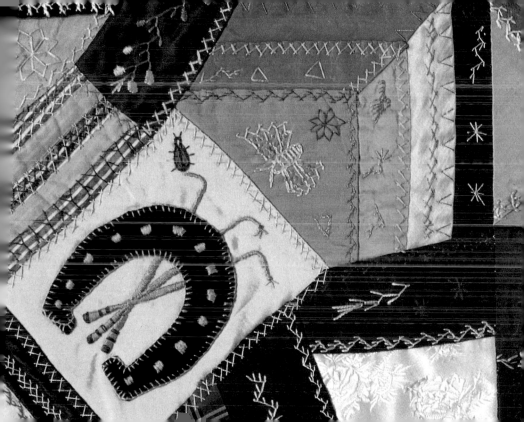

Ram's Head. Egyptian, ca. 304–30 B.C., Ptolemaic Period. Limestone. Gift of Edward S. Harkness, 1918 18.9.1.

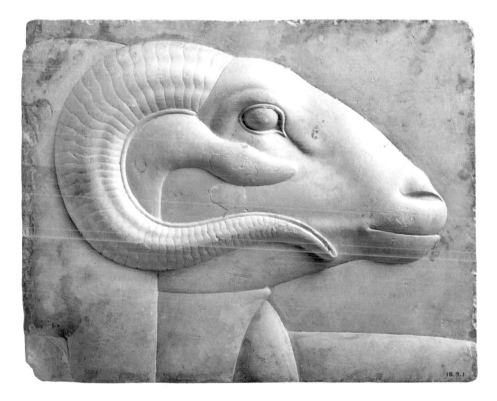

Rat Snake. Detail of a page from *A Book of Insects and Reptiles*. Kitagawa Utamaro, Japanese, 1753–1806. Woodblock print in colors, Edo period (1615–1867), 1788. Rogers Fund, 1918 JP 1052.

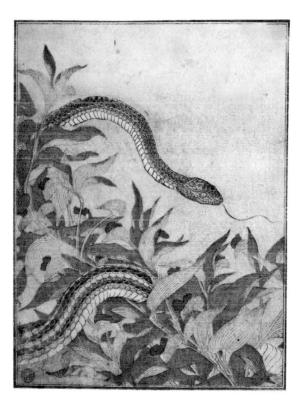

Thanksgiving Turkey. Grandma Moses (Anna Mary Robertson Moses), American, 1860–1961. Oil on wood, 1943. Bequest of Mary Stillman Harkness, 1950 50.145.375.

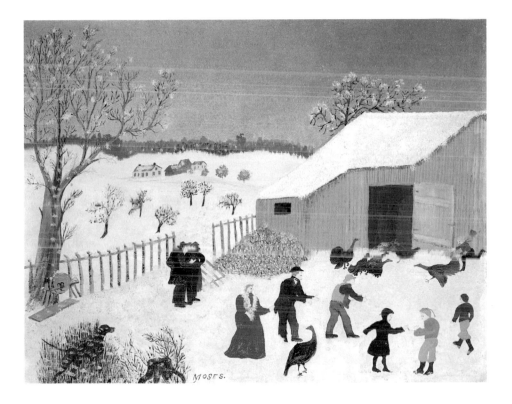

Young Duck. Harry Dickinson Thrasher, American, 1883–1918. Bronze, ca. 1914. Rogers Fund, 1918 18.120.

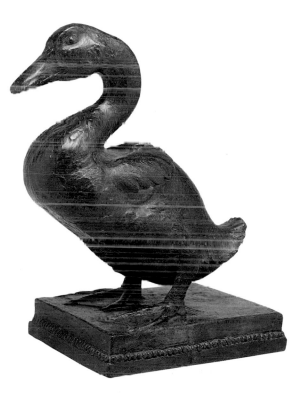

Unicorns. Arthur B. Davies, American, 1862–1928. Oil on canvas, 1906. Bequest of Lillie P. Bliss, 1931 31.67.12.

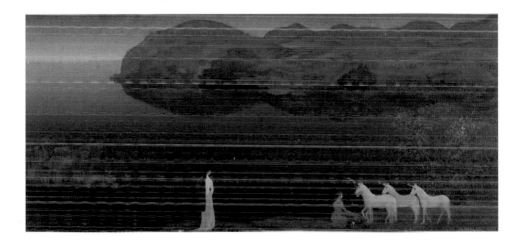

WATCH-DOGS

Left: **Watch.** Leger, Paris (France), ca. 1780–90. Gold, painted enamel, and pearls.
Right: **Watch.** Probably Swiss, late 18th century. Gold and painted enamel.
Bequests of Mrs. George A. Hearn, 1917 17.101.23, 17.101.27.

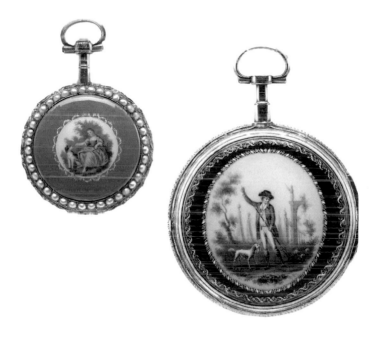

Scene in a Papyrus Swamp. Facsimile of a painting from the Palace of Amenhotpe III. Egyptian, Thebes, Dynasty 18, ca. 1390–1353 B.C. Rogers Fund, 1930 30.4.133.

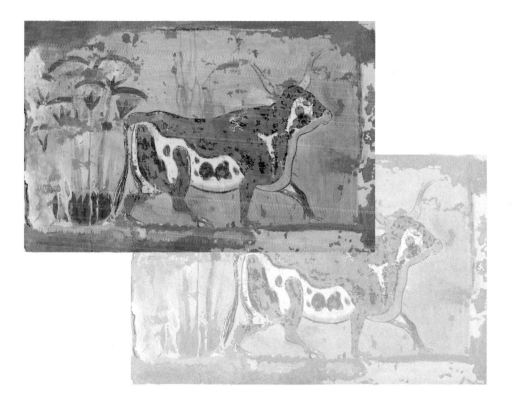

Fighting Yaks. Wu Tso-jen, Chinese, b.1908. Detail from a hanging scroll, ink on paper; 1947. Gift of Robert Hatfield Ellsworth, in memory of La Ferne Hatfield Ellsworth, 1986 1986.267.392.

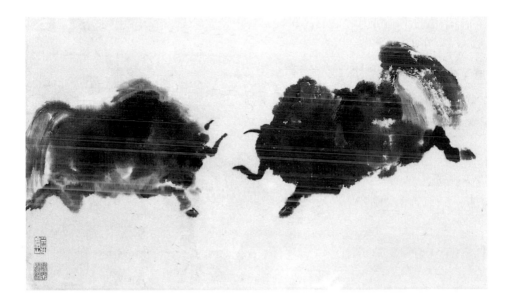

Zebra and Colt. Weegee (Arthur Fellig), American (b. Hungary), 1899–1968. Gelatin silver print, 1945 or before. The Elisha Whittelsey Collection, The Elisha Whittelsey Fund, 1977 1977.532.

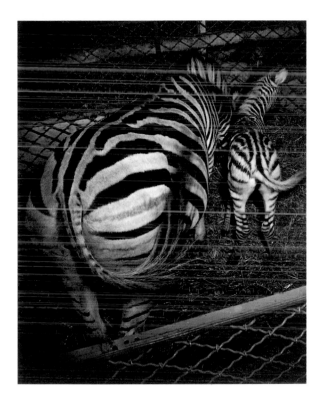

Front jacket and last page:
adapted from *"Monkey" Wine Glass*
Josef Hoffmann, Austrian, 1870–1956, and
Ludwig Heinrich Jungnickel (decorator), Austrian, 1881–1965
Painted glass, 1910–11
Manufactured by J. & L. Lobmeyr for the Wiener Werkstätte
The Cynthia Hazen Polsky Fund, 1993 1993.323

Back jacket: *Zebra and Colt*
Weegee (Arthur Fellig), American (b. Hungary), 1899–1968
Gelatin silver print, 1945 or before
The Elisha Whittelsey Collection
The Elisha Whittelsey Fund, 1977 1977.532

Grateful acknowledgment is made for permission
to use the following copyrighted material.
Lighter in the Form of a Fish by Jean Schlumberger
reproduced by permission of Tiffany & Co.
KITTY LITTER® is a registered trademark of Ralston Purina Company.
Used with permission.
Thanksgiving Turkey by Grandma Moses: Copyright © 1987,
Grandma Moses Properties Co., New York.
Xerox name courtesy of Xerox Corporation.
Zebra and Colt by Weegee © 1994, International Center of Photography,
New York, Bequest of Wilma Wilcox.

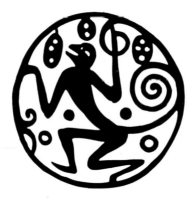